INTRODUCTION AND ACKNOWLEDGMENTS

Anne Leonard

Some exhibitions are forced in[to] come about naturally, almos[t] morning in late January tha[t] Charles Hack's possession, collected by him over the prior five or six years, began stacking up on the piano in his Manhattan apartment and forming clusters. Before our eyes, over and over again, three, five, or even seven impressions of a single composition would arrange themselves into series that mapped the evolution of Buhot's thought and practice on individual etched copperplates. That was when I knew an exhibition was in the making.

I've overplayed the "magical" aspect of the print viewing and sorting that day for dramatic effect, of course. It hardly needs stating that human hands pulled the prints out of boxes and folders, and assembled them in logical order. But the allusions to sorcery that often attach to Buhot, even in critical appreciations from his own era, could not help but cast an aura over the proceedings. An unidentified critic in 1880 referred to the "devil's brew" of intaglio techniques used by Buhot, and this, combined with his penchant for macabre imagery, would seem to justify the title of sorcerer.[1]

Known to works-on-paper enthusiasts as a relentlessly experimental printmaker of the 1870s and 1880s, Félix Buhot (1847–1898) nonetheless remains a relatively obscure artist compared with Etching Revival standard-bearers of a generation earlier, such as James McNeill Whistler and Félix Bracquemond. Buhot was highly collected by Americans from early days, and his first retrospective (in 1888) took place in New York, not France. Yet he is still a rather specialized taste in this country, despite links with popular art movements like Impressionism and *japonisme*.

The essence of the "collectable" Buhot has always resided in his individuation of single impressions—a practice that, taken to its extreme, would seem to challenge the fundamental status of the print as a multiple. Not only did Buhot produce as many as fifteen states for one print (for example, *The Cab Stand*), he also achieved exceptional variation among multiple printings within a single state. By changing the paper, the ink color, and/or the technique of wiping the plate, Buhot was able to make each impression into a quasi-unique object. He often personalized these further with annotations, dedications, and (for his most favored impressions) his signature red-owl stamp.

Moreover, Buhot's "symphonic margins" functioned much like sketch pads for aesthetic ideas in development and were especially prized by discerning collectors of proof states, who knew that those bonus scenes would likely be removed before the final version.

Rembrandt is usually cited as the paramount influence and inspiration for printmakers of the Etching Revival— and a bust of Rembrandt indeed appears in the top margin of Buhot's frontispiece to Henri Béraldi's *Les graveurs du XIXe siècle*. Yet it is illuminating to point out, as Charles Hack has done, that a more apt model for Buhot's idiosyncratic print practice may be the older and lesser known Dutch artist Hercules Segers (1589/90–1633/40). Segers, too, challenged typical definitions and boundaries of printmaking by experimenting with different grounds, printing on unusual supports, painting over printed impressions, and using chance elements to yield greater differentiation.

Buhot's distinctive place in the history of printmaking would on its own be sufficient reason to mount a display of his works. As it happens, this exhibition resulted from a confluence of three factors, each one decisive for the realization of the

Theme and Variations:
The Multiple Sorceries of Félix Buhot

Edited by Anne Leonard

SMART MUSEUM OF ART
THE UNIVERSITY OF CHICAGO

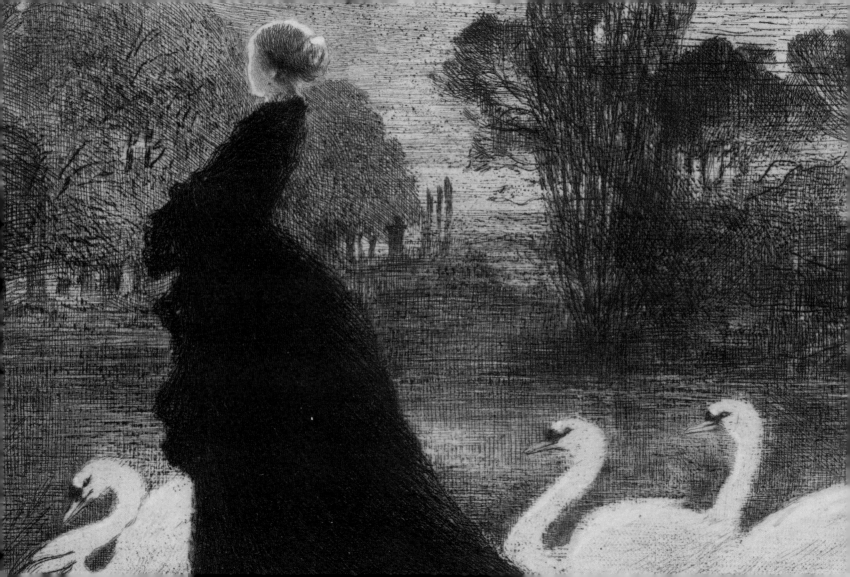

project. The first was the ambitious spring 2018 Smart Museum exhibition project *Expanding Narratives: The Figure and the Ground*, whose primary focus on modern and contemporary painting and sculpture opened up a space for a complementary presentation of works on paper. Addressing similar questions of the dissolution of figure and ground in the realm of printmaking, *Theme and Variations: The Multiple Sorceries of Félix Buhot* offered a concurrent, single-artist counterpoint to the larger exhibition. I am deeply grateful to Alison Gass, Dana Feitler Director of the Smart Museum, for her support, her openness and flexibility, and her insightful thinking about the relationship between the two projects.

The second significant element making this exhibition possible was the willingness of collector Charles Hack and the Hearn Family Trust to make the works available at short notice. It is a truism that a loan show could not be done without the cooperation of the lender; certainly, without that consent, the works would not and could not travel. But Charles's role extended well beyond. As this was his first time sending any of the Buhot prints out for exhibition, mats, frames, and glazing all had to be readied from scratch; with maximum efficiency, he also ensured that conservation and photography got done in time. His magnanimity, unstinting effort, and full-on engagement in all the nuts and bolts of preparation amount to something extraordinary, and we are tremendously grateful. It is a pleasure also to recognize those others whose expertise and quick footwork contributed to the exhibition's timely opening: Yana van Dyke, Molly Bauer, Susan Schulman, Ron Yourkowski, Ron Glazer, and Bruce Schwarz.

A final element of good fortune in the timing of this exhibition is that it directly followed a course I taught on nineteenth-century European prints, in the University of Chicago's Department of Art History in winter quarter 2018. The course was open to both graduate and undergraduate students and included an optional curatorial practicum. In normal circumstances, this would have consisted of a response exhibition drawing upon the collections of the Smart Museum, from which the course was exclusively taught. This time, an unprecedented bonanza of Buhot prints was at our fingertips. Three-quarters of the class's sixteen students signed up, willingly offering their time and effort—even

during spring break!—to help with object selection, conduct needed research, and craft exhibition labels. I am pleased and proud to acknowledge all twelve student curators who joined our Buhot adventure: Megan Beckerich, Rafaela Brosnan, Alina Cui, Kate Fuell, Kris Lipkowski, Cameron Robertson, Charlotte Saul, Natalie Smith, Andrea Tabora, Julia Walker, Lydia Wu, and Adeline Yeo. Their interpretive texts form the backbone to this volume.

1. For the quotation, see Jay McKean Fisher and Colles Baxter, *Félix Buhot, Peintre-Graveur: Prints, Drawings, and Paintings* (Baltimore: The Baltimore Museum of Art, 1983), 26. This exhibition catalogue remains the best English-language reference for Buhot, along with James Goodfriend's 1979 update to the Gustave Bourcard catalogue raisonné of Buhot's prints.

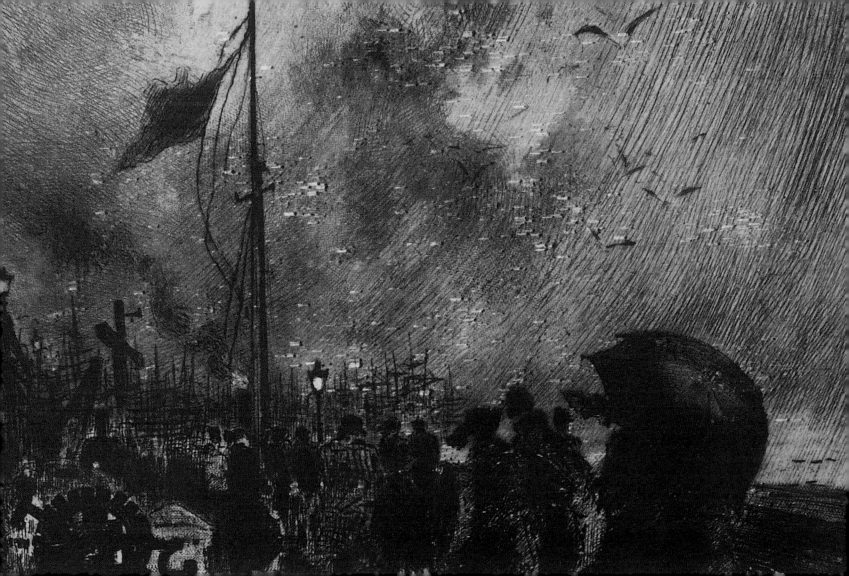

The following catalogue documents all the works shown in the Smart Museum exhibition *Theme and Variations: The Multiple Sorceries of Félix Buhot* (April 24–July 22, 2018).

All works by Félix Buhot (French, 1847–1898) unless otherwise indicated. All works owned by the Hearn Family Trust unless credited otherwise.

B/G numbers refer to the Bourcard/Goodfriend catalogue raisonné: *Félix Buhot: Catalogue descriptif de son oeuvre gravé*, ed. Gustave Bourcard, with additions and revisions by James Goodfriend (New York: Martin Gordon, Inc., 1979).

Japonisme
B/G 11–20
1885
Etchings on paper, dimensions variable

This series was commissioned by the art critic Philippe Burty, a friend of Buhot's. Burty chose objects from his Japanese collection to challenge the young Buhot to reproduce three-dimensional form through etching.

Burty had coined the term *japonisme* to refer to the late-nineteenth-century European interest in Japanese aesthetics. He was one of the first to collect Japanese objects, such as paintings, lacquerware, bronzes, and wood carvings, which became fashionable in European society. He was delighted with Buhot's etchings and declared that *japonisme* "has never had a more intelligent or exact interpreter."[1]

The precision with which Buhot reproduced these objects shows his skills as an etcher. However, his stated goal was to "render above all . . . the impression."[2] In doing so, he brought a warmth to these reproductions that anticipated his later talent for conjuring mood and atmosphere.

—Megan Beckerich and Adeline Yeo

1. Burty's comment, from an article he published in *Harper's New Monthly Magazine* in February 1888, is cited in Phillip Dennis Cate, "Félix Buhot & Japonisme," *The Print Collector's Newsletter* 6, no. 3 (1975): 64.
2. This phrase comes from an 1875 letter to fellow etcher Jules Jacquemart and is quoted in Jay McKean Fisher and Colles Baxter, *Félix Buhot, Peintre-Graveur: Prints, Drawings, and Paintings* (Baltimore: The Baltimore Museum of Art, 1983), 93.

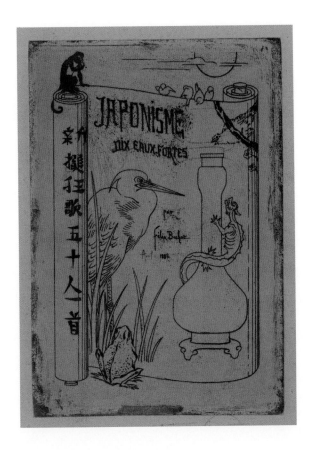

Left:
Titre (Title)
B/G 11, third state

Others in the series (not illustrated):
Masque en Bois (Wooden Mask)
B/G 12, fourth state

Pharmacie Ivoire (Ivory Medicine Holder)
B/G 13, third state

Génie Bronze (Bronze Genie)
B/G 14, third state

Boîte à Thé Porcelaine (Porcelain Tea Jar)
B/G 15, third state

Vase Étain Laqué (Lacquered Tin Vase)
B/G 16, third state

Cavalier Bronze (Bronze Horseman)
B/G 17, second state

Crapaud Bronze (Bronze Toad)
B/G 18, third state

Barque de Dai-Ko-Ku, Bois (Wooden Boat of Dai-Ko-Ku)
B/G 19, first state

Ex-Libris Papillon et Libellule (Butterfly and Dragonfly Bookplate)
B/G 20, third state

Spleen et Idéal ou le Fiacre aux Amours
(Spleen and Ideal or the Cab with Cupids)
B/G 73
1876

This etching's emotionally charged title is taken from Charles Baudelaire's notorious poetry collection *Les Fleurs du Mal*, first published in 1857. Describing dualities such as the physical and spiritual, the volume expressed the poet's notions of perfection, as well as his depths of despair. This illustration's horse-drawn carriage is a frequent motif in Buhot's work, but the hovering swarm of cherubic heads invests the nocturnal cab ride with an air of the supernatural, while also permitting the artist to elaborate the brooding atmospheric effects that were a hallmark of his works.

A counterproof is made by pressing a sheet of paper onto the still-wet proof, thus yielding a reverse image meant to reveal imperfections in the printing plate. Although the counterproof is typically lighter than the original, Buhot has significantly darkened this one by reworking it in aquatint and drypoint. The work is dedicated to Norbert Goeneutte (1854–1894), a fellow Parisian painter and etcher.

—Kris Lipkowski

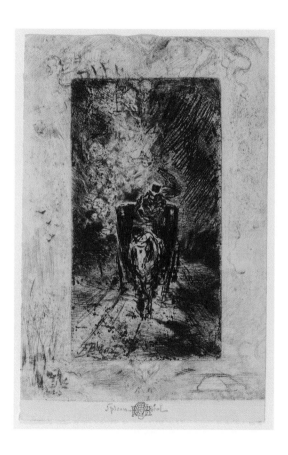

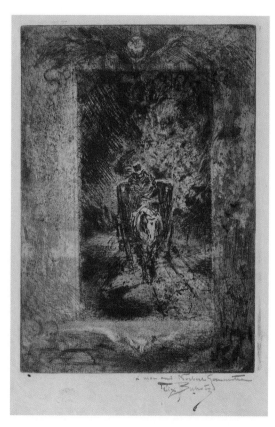

Left:
Between first and second state
Etching on paper
plate: 8⅝ x 5⅝ in.,
sheet: 14⅛ x 10⅜ in.

Right:
Counterproof of second state
Etching, aquatint and drypoint on
wove greaseproof paper
plate: 8⅜ x 5⅞ in.,
sheet: 10⅞ x 8½ in.

Une Matinée d'Hiver au Quai de l'Hôtel-Dieu
(The Cab Stand)
B/G 123
1876

The Cab Stand is one of Buhot's most famous prints and a characteristic example of his experimental technique. In addition to using the traditional method of etching, Buhot incorporated drypoint and modified the wiping of the plate in order to capture the atmospheric effects of wind, rain, and fog.

This series of prints also reveals Buhot's artistic process as he altered the image from an early preparatory drawing through various states; the final print is marked by his signature red owl stamp. Each proof shows slight variation, such as marginal notations or distinct shading patterns to suggest different weather conditions in each scene. Buhot also changed the margins between the preparatory drawing (which is actually executed on a photograph) and subsequent states. He gradually added more compositional elements, such as chimneys at upper right and a sidewalk at bottom left. These particularities would have allowed Buhot to sell the different impressions as individual, unique works—highly valued by nineteenth-century collectors for the insight they gave into the artist's creative process.

—Lydia Wu and Natalie Smith

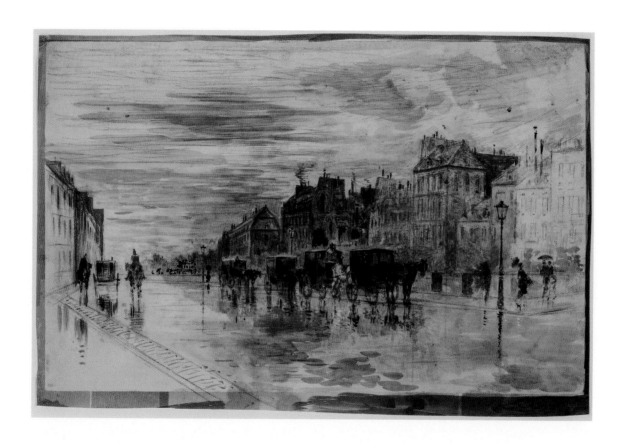

Black and brown ink over brown, gray, and white washes over black crayon on photographic paper, 8 x 12¼ in.

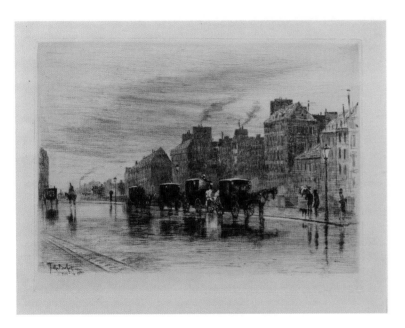

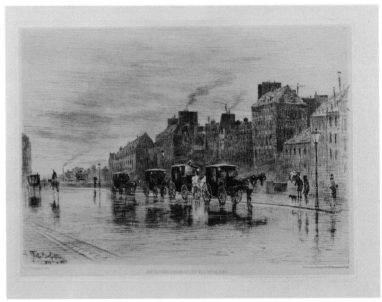

Second state
Etching and drypoint on paper
plate: 9⅜ x 12¾ in., sheet: 11 x 14¼ in.

Fifth state
Etching and drypoint on paper
plate: 9⅜ x 12¾ in., sheet: 11¾ x 15⅞ in.

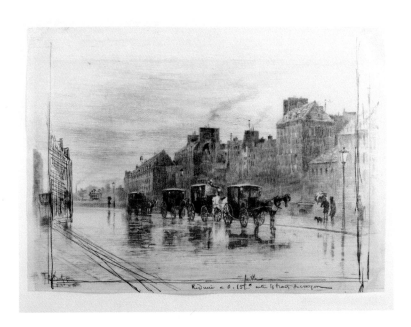

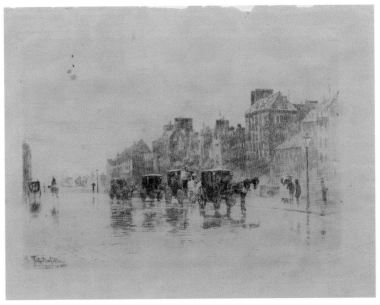

Fifth-sixth state
Etching and drypoint on paper, trimmed to plate, with pen indicating plate
alterations, sheet: 9¼ x 13 in.

Seventh state
Etching on paper
plate: 9⅜ x 12¾ in., sheet: 11¼ x 17⅛ in.

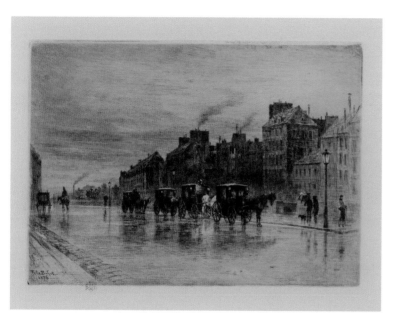

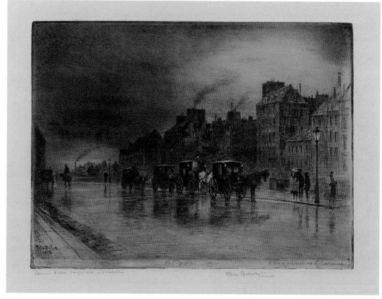

Tenth state
Etching and drypoint on paper
plate: 9¼ x 12¾ in., sheet: 13⅝ x 17⅜ in.

Fourteenth state
Etching and drypoint on paper
plate: 9⅜ x 12¾ in., sheet: 13⅞ x 18⅝ in.

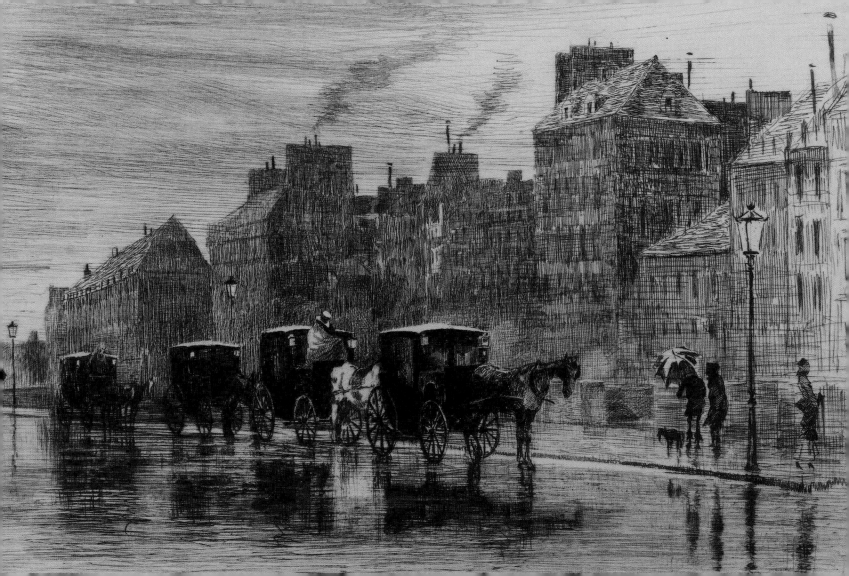

La Fête Nationale au Boulevard Clichy
(National Holiday on the Boulevard Clichy)
B/G 127
1878

This etching illustrates the patriotic festivities of June 30, 1878, which celebrated the Universal Exposition in Paris and commemorated a donation of new flags by the president of France, a former general and military hero.

Set on Boulevard Clichy, home to Buhot's studio, the scene depicts a well-dressed bourgeois family walking along a clean, open, flag-adorned street. Across different states of the print, Buhot used the margins to offer animated sketches of a lively urban public. Boys parade through the streets with lanterns and umbrellas, while children converse with a soldier, a reminder of the recent war with Germany.

La Fête Nationale stages the virtues of the city and promotes an official view of the well-ordered republic. Yet the prominent lamppost, a symbol of innovation and progress in the City of Light, receives unceremonious treatment by the dog in the foreground, thus complicating a simple nationalistic reading.

—Charlotte Saul

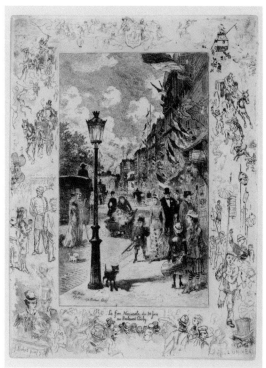

Left:
First state
Etching on paper
plate: 12½ x 9¼ in., sheet: 13⅜ x 9⅞ in.

Right:
Fifth state
Etching, drypoint, aquatint on paper
plate: 12⅜ x 9¼ in.,
sheet: 20 x 14¼ in.

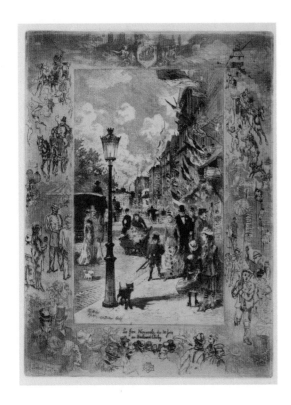

Seventh state
Etching, drypoint, aquatint on paper
plate: 12½ x 9⅜ in., sheet: 17½ x 11¾ in

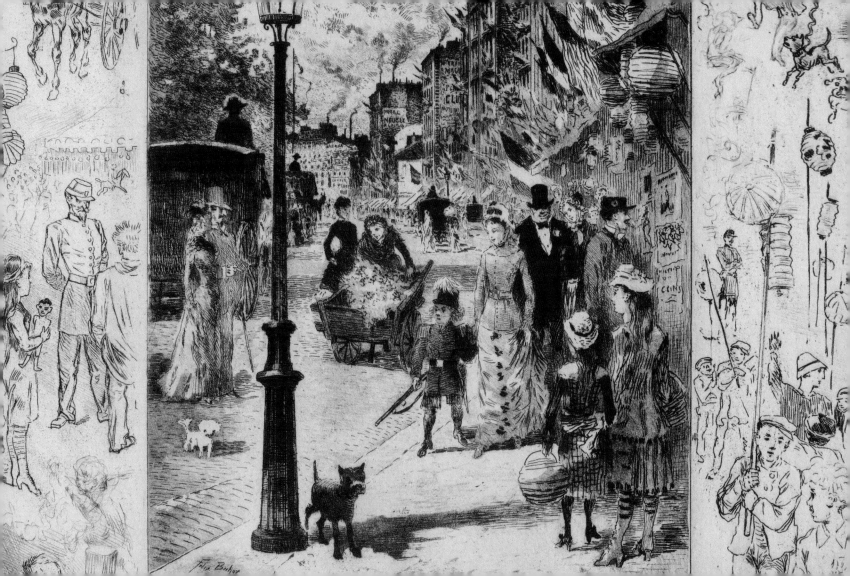

Un Débarquement en Angleterre
(A Landing in England)
B/G 130
1879

In what Buhot considered his most characteristic print, figures shield themselves from the stormy weather on an English pier, where they have just landed after a ferry crossing from France. By combining experiments in printing technique with the use of different papers, Buhot creates atmospheric effects that individualize each print. The contrasts between impressions result from Buhot's variations in tonal effects to introduce subtle distinctions in lighting.

—Kate Fuell and Julia Walker

As he often did, Buhot surrounded the main image with *marges symphoniques*—small vignettes, here occupied with sketches of passengers, umbrellas, slick silhouettes and their puddled reflections. He removed these marginal images between the fourth state, which he considered his best work, and the fifth, long thought to be the final state. A previously undescribed sixth state, unearthed during the preparations for this exhibition, makes its debut here. Into a scene of already unsettled weather, Buhot introduces a remarkable snow effect: with staccato scoring of the plate, he conjures up white flurries in the sky.

—Charlotte Saul and Kris Lipkowski

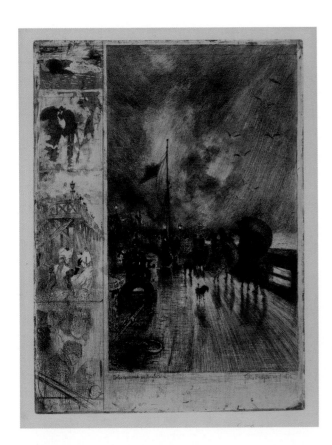

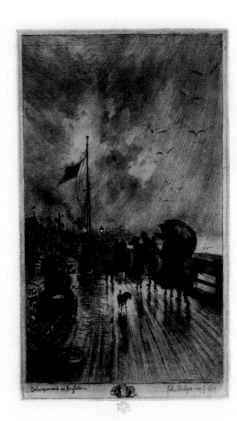

Left:
Fourth state
Etching, drypoint, aquatint,
and stipple engraving
plate: 12⁹⁄₁₆ x 9⅜ in.,
sheet: 15¾ x 10½ in.
Smart Museum of Art, Purchase,
The Paul and Miriam Kirkley Fund
for Acquisitions
2010.115

Right:
Fifth state
Etching, drypoint, aquatint,
and roulette on laid paper
plate: 11¾ x 7 in.,
sheet: 15 x 9⅛ in.
Smart Museum of Art, Gift of
Brenda F. and Joseph V. Smith
2003.27

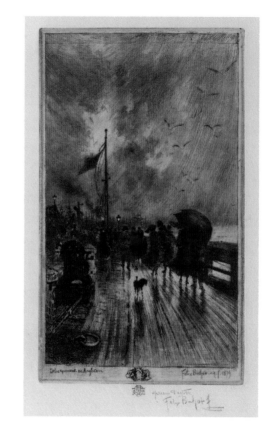

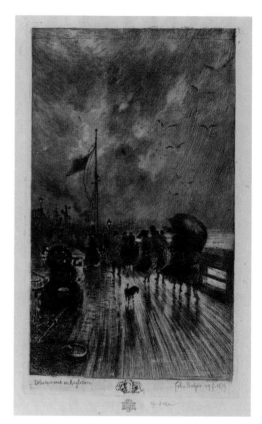

Left:
Fifth state
Etching, drypoint, aquatint and
roulette on light-stained blue paper
plate: 11¾ x 7 in., sheet: 14⅞ x 10¾ in.

Right:
Fifth state
Etching, drypoint, aquatint and roulette on paper
plate: 11¾ x 7 in., sheet: 13⅝ x 9⅛ in.

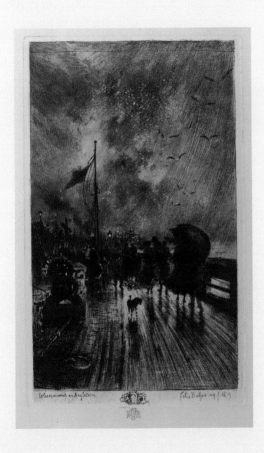

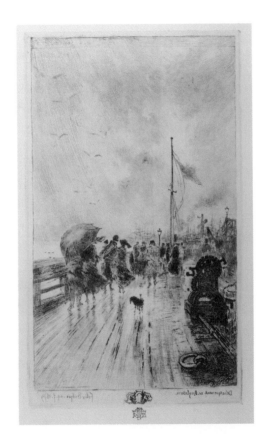

Left:
Undescribed sixth state, with plate scored to create snowfall and the central lamplight enlarged
Etching, drypoint, aquatint and roulette on paper
plate: 11¾ x 7⅛ in., sheet: 13¾ x 10¼ in.

Right:
Counterproof, fifth state
Etching, drypoint, aquatint, and roulette on tan paper
plate: 11¾ x 7⅛ in.,
sheet: 16⅜ x 10¼ in.

Une Jetée en Angleterre **(A Pier in England)**
B/G 132
1879

Une Jetée en Angleterre reverses the composition of the previous prints, offering an excellent demonstration of the artistic process as well as the effects of different printmaking techniques. This work particularly highlights Buhot's ability to dramatically alter the mood of a print without drastic changes to the composition. The first state, though sketchy with large areas of white space, has a rich, saturated appearance owing to its use of drypoint. Subsequent states reveal the addition of more intricate details and the introduction of new techniques in order to depict a wide variety of climatic conditions.

A virtuosic and careful artist, Buhot protected his ownership by "canceling" (crossing out with score marks) plates that he did not want further circulated. The dark lines running through the canceled plate ensured that it could not be used to print additional impressions, thus preserving the exclusivity of the image.

—Kate Fuell and Julia Walker

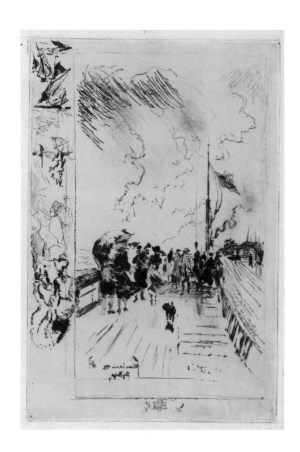

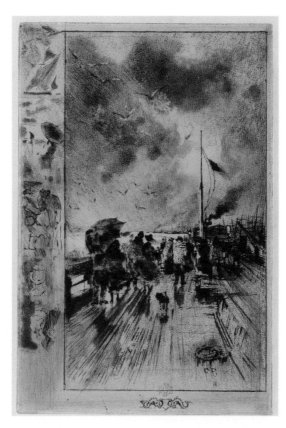

Left:
First state
Drypoint and roulette on paper
plate: 11¾ x 7⅞ in.,
sheet: 12¼ x 8½ in.

Right:
Second state
Drypoint and aquatint on paper
plate: 11¾ x 7⅞ in.,
sheet: 17⅝ x 12¼ in.

Left:
Fifth state
Drypoint on paper
plate: 11¾ x 7⅞ in.,
sheet: 14⅞ x 11⅛ in.

Right:
Possibly seventh state
Etching on flecked paper,
chine appliqué dusted with gold
plate: 11¾ x 7⅞ in., sheet: 17 x 12 in.
Dedicated to the artist Jules Chéret;
further annotated in pen and ink

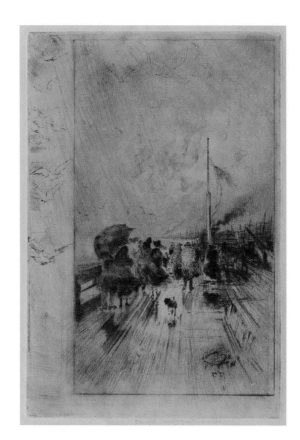

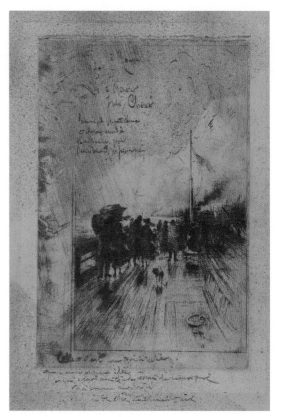

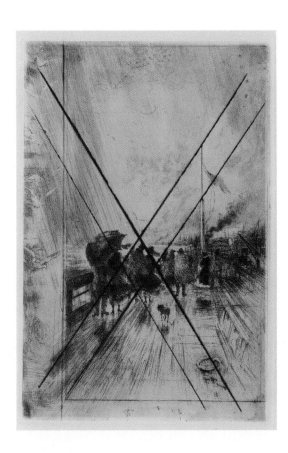

Canceled plate
Etching on paper
plate: 11¾ x 7⅞ in., sheet: 19¾ x 12⅞ in.

La Traversée (The Crossing)
B/G 143
c. 1879

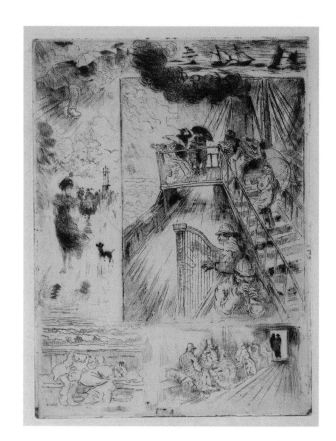

At first glance, *La Traversée* is a chaotic depiction of ship passengers hustling in the windy weather. Whereas the pier scene in the left margin is a direct import from the main image of *Un Débarquement en Angleterre* and *Une Jetée en Angleterre*, the harpist and seasick passengers here suggest a deliberate reference to Richard Wagner's operatic drama, *Tristan und Isolde*, in which a Cornish knight, Tristan, is charged with bringing the princess Isolde across the Irish sea as a bride for his uncle. At one point Isolde calls for the seas to rise up and destroy the ship; at another, she and Tristan drink what they believe to be poison, actually a love potion. In some versions of the legend, she falls for Tristan because he plays the harp so beautifully.

After the first state, Buhot added the inscription, in English, "A Holyday / Rain, Storm and Music." The third-state impressions shown here are printed in two different ways. In one, Buhot added a second ink color (brown) to the main image, adding warmth. In the other, the paper has been soaked in turpentine to give an orange tone.

—Alina Cui

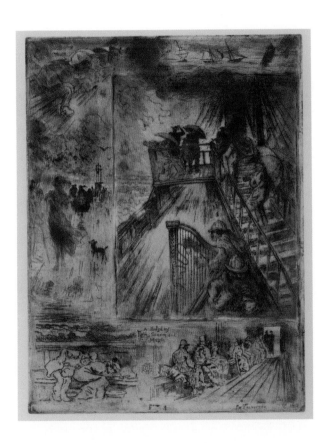

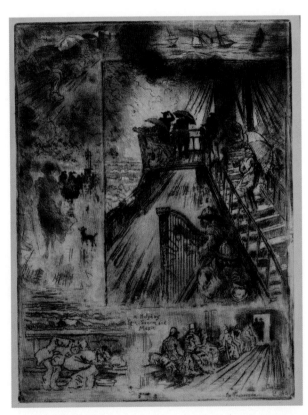

Opposite page:
First state
Etching on off-white
laid paper
plate: 12⅝ x 9⅜ in.,
sheet: 17¼ x 11⅞ in.

Left:
Third state
Etching and aquatint
on paper, with brown ink
in image and black ink
in margin
plate: 12⅝ x 9½ in.,
sheet: 19⅛ x 13⅞ in.

Right:
Third state
Etching and aquatint on off-
white laid paper, printed "à
l'essence" to give orange tone
plate: 12⅝ x 9⅝ in.,
sheet: 14½ x 10⅞ in.

La Dame aux Cygnes **(Lady with Swans)**
B/G 144
1879

La Dame aux Cygnes uses the purely linear features of etching to achieve a range of shades from black to white. A woman walks on a shore, parallel to swans in the water below. Despite the etching's dark coloration, which in other Buhot etchings can suggest threatening weather, the scene conveys an underlying peace: the woman's walk seems leisurely, and the swans follow alongside in a similar manner. The black of the woman's dress contrasts with the pure white of the swans. Faint lines etched onto the swans' bodies replicate the look of feathers and give the forms more texture. Both prints are third states that include Buhot's signature red stamp, but because the honeycomb paper used in the first can hold more ink, it yields a richer texture. The bottom text reads, "Memory of Barham Court Kent, from a sketch by Mrs. E. V. B." While Mrs. E. V. B. has not been identified, Barham Court was an estate in Kent, England, that Buhot once visited.

—Cameron Robertson

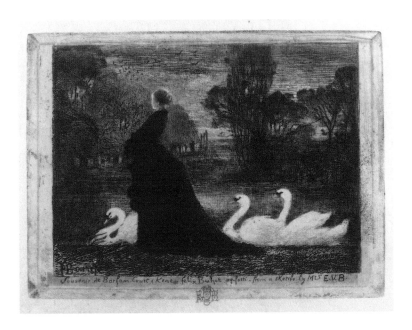

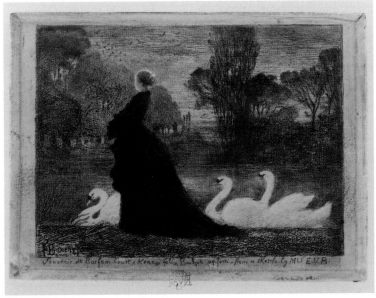

Third state
Etching on honeycomb paper
plate: 5⅛ x 7⅛ in., sheet: 10⅛ x 13 in.

Third state
Etching on paper
plate: 5⅛ x 7⅛ in., sheet: 8⅝ x 11¼ in.

Les Voisins de Campagne (Country Neighbors)
B/G 148
c. 1879–80

This print demonstrates Buhot's penchant for amusing figures with umbrellas and small dogs. Yet there is a substantial difference between the first state, with its spare line work on an oversized sheet, and the final state, which illustrates sophisticated atmospheric effects.

The first state reveals the conceptual influence of Japanese art on Buhot: the delicate, precise lines recall traditional Japanese woodblock prints and highlight his interest in line and paper quality—obsessions of Japanese printmakers of the time, too. However, before fleshing out the details in later states, Buhot had a change of mind about the plate size he had chosen. Realizing that he needed only the upper half of the plate for his image, he cut off the excess so that remaining impressions would be printed in a landscape format.

Les Voisins de Campagne showcases Buhot's interest in depicting daily life and familiar characters, as well as his fascination with weather and sky. The sophisticated manipulation of line etching and drypoint (together mimicking aquatint) makes a dramatic difference in the ability to shade and render three-dimensional objects, highlighting Buhot's skill in the intaglio medium.

—Megan Beckerich

First state
Etching on paper, plate: 9¾ x 7 in., sheet: 12 x 9 in.

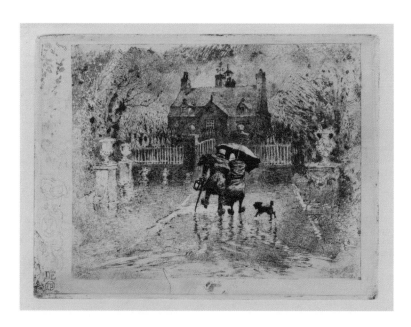

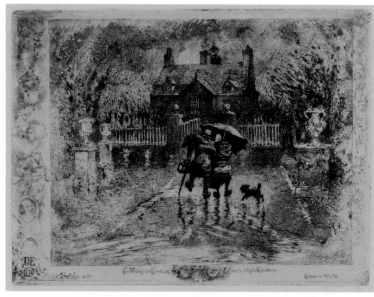

Third state
Etching and drypoint on paper
plate: 5⅜ x 7⅛ in., sheet: 6½ x 7⅞ in.

Fifth state
Etching and drypoint on Japan paper
plate: 5¼ x 7⅛ in., sheet dimensions unavailable due to framing

Le Petit Enterrement (The Little Burial)
B/G 154
1878

Le Petit Enterrement, second state,
New York Public Library

Le Petit Enterrement's small scale presents a unique perspective that departs from the typical scenes of busy Paris streets, offering a more intimate view of a small gathering for a burial. These two impressions differ only in ink color, illustrating Buhot's tendency toward technical variation for creative purposes. This print incorporates brown and blue, but other versions include different colorations—even the application of gold paint—as well as writing in the margins (see example at left). The effect of the different ink colors is subtle, but the depth and tonal variation achieved by the blue ink soften the somber scene and emphasize the watery reflections on the street. This may be what earned the blue print Buhot's signature red-owl stamp, which he often used to mark his best impressions.

—Rafaela Brosnan

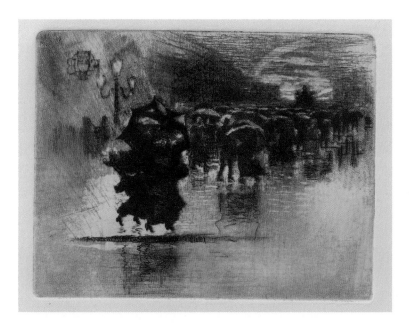

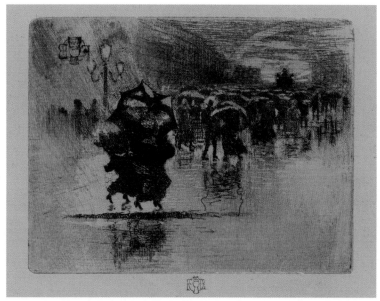

Second state
Etching with roulette and aquatint; brown ink on wove paper
plate: 3½ x 4½ in., sheet: 8⅜ x 11⅜ in.

Second state
Etching with roulette and aquatint; blue ink, stamped on paper
plate: 3½ x 4⅝ in., sheet: 5½ x 8 in.

Le Hibou (The Owl)
B/G 161
1883

One of Buhot's favored motifs, the owl also became his "seal of approval" in the form of a red stamp. In this print, however, the margins occupy a larger area than the central image and arguably draw attention away from the owl perched next to a book. The border offers an amalgamation of Buhot's other major motifs, drawn from his book illustrations and prints: an eerie full moon, a spooky lantern, and an array of shadowy figures. Buhot seamlessly combined his interest in the macabre with his characteristic depictions of ships and horse-drawn carriages. The print displaying the red-owl stamp is the final state, and it bears compositional differences from its predecessors. In the lower right-hand corner, for example, it depicts a house where previous states show only ambiguous shadows. The words *pauca paucis*—Latin for "a few for the few"—have been added, as well, showing the print's (unrealized) purpose as the frontispiece to a selection of Buhot's largest prints. This print is a departure from certain other Buhot images, in which the border was seen as dispensable for the final state.

—Lydia Wu

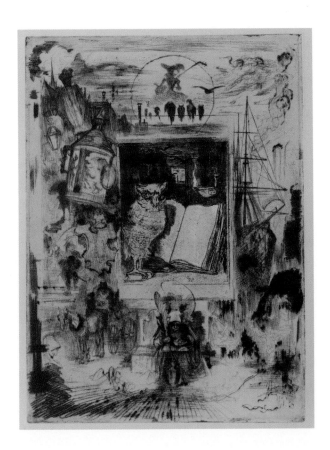

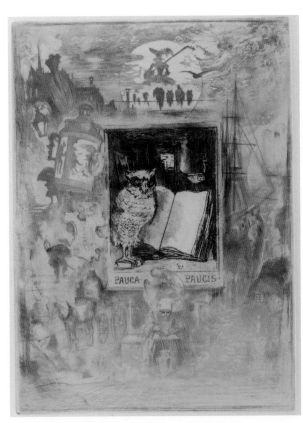

Left:
Second state
Etching, drypoint, and
roulette on paper
plate: 17½ x 12⅞ in.,
sheet: 21½ x 14⅜ in.

Right:
Fifth state
Etching, drypoint, and
aquatint on paper; greenish
ink for margins, black ink
for central image
plate: 17¾ x 12⅞ in.,
sheet: 22¾ x 16⅞ in.

La Place des Martyrs et la Taverne du Bagne
(The Place des Martyrs and the Jailhouse Tavern)
B/G 163
1885

Here Buhot depicts the lively crowds outside the Taverne du Bagne, a bar established during the Paris Commune of 1871. This tavern, a short walk from Buhot's home, was a peculiar institution of Parisian social life where wait staff dressed as prisoners and prison guards.

This set of prints exhibits dramatic variation from the first state, which portrays a daytime scene, to the last state, in which Buhot used heavy plate tone and brown ink to render a more ominous, nocturnal image. The scene is surrounded on all sides by Buhot's "symphonic margins," small vignettes framing the central image that were sometimes removed from the final state. Below, Buhot set the tone with lines from a poem by Jean Le Fustec:

While they were bound to eternal labors,
By the implacable grip of chains,
Bearing the mark of galley-slaves in the midst of hell,
And spitting out their rancor in foul curses.
Oh convicts! All the good their misery inspires
Is to beat the bass-drum with these regrets.
Here the passerby finds amusement in a shackle,
And the chain clinks in penny-pieces on the counters.[1]

—Natalie Smith

1. Translation from Jay McKean Fisher and Colles Baxter, *Félix Buhot, Peintre-Graveur: Prints, Drawings, and Paintings* (Baltimore: The Baltimore Museum of Art, 1983), 115.

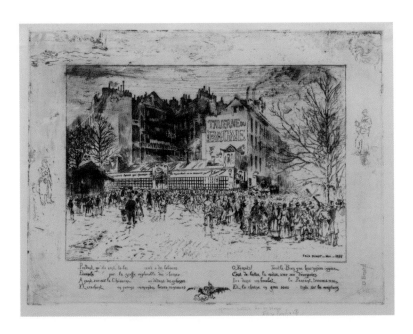

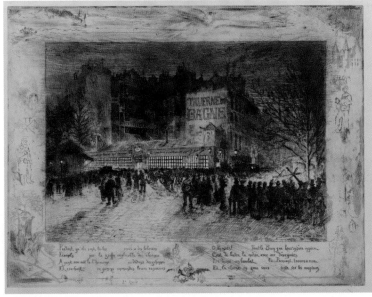

First state

Etching and aquatint on paper

plate: 13⅜ x 17⅝ in., sheet: 16¾ x 24 in.

Second state

Etching and aquatint on paper

plate: 13¼ x 17½ in., sheet: 14 x 19½ in.

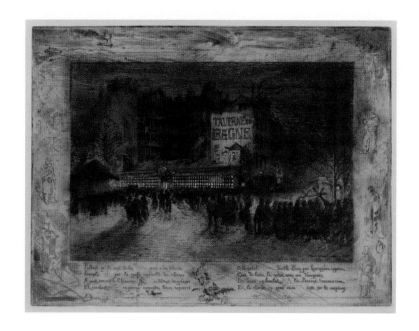

Third state
Etching and aquatint on paper
plate: 13¼ x 17½ in., sheet: 15 x 22 in.

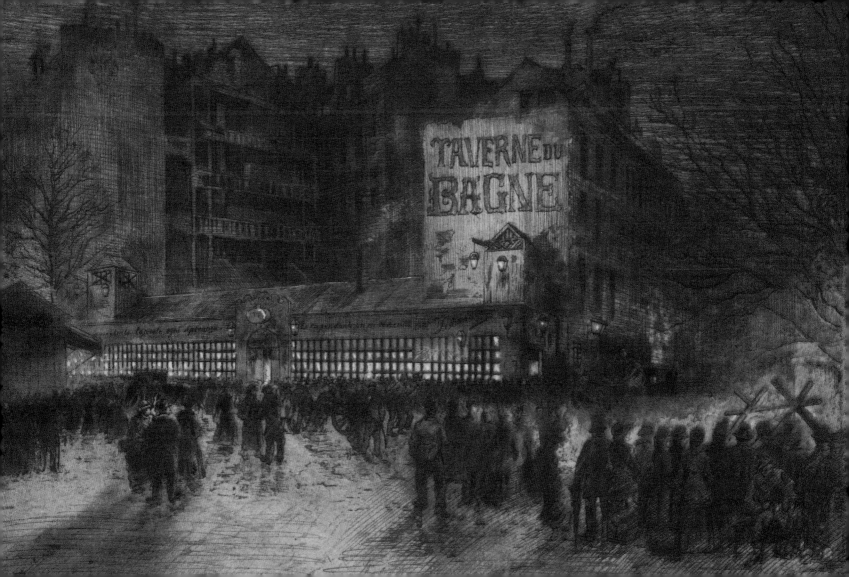

Frontispice pour **Les Graveurs du XIXe siècle,**
de Henri Béraldi
B/G 164
c. 1884–86

Commissioned by Henri Béraldi as the frontispiece to his dictionary of nineteenth-century engravers, this work saw many adjustments in its evolution from first to final state. In the first state, Buhot depicts two men in the middle of a boulevard, announcing the work's title and publisher by placard. By the sixth state, the content and shape of the margins have changed dramatically, most notably with the addition of a bust of Rembrandt—revered by nineteenth-century French etchers—at top center. Other significant elements in the margins include the titles of works by admired art critic Philippe Burty and cityscapes of London and Paris.

Although the margins were cut off in the plate's seventh and final state, Béraldi would publish an additional hundred copies of *Les Graveurs* with the plate's sixth state on larger paper. As detailed in a letter from Béraldi to Buhot, this exclusive "triumph" of a publication included the frontispiece with "symphonic margins."

—Charlotte Saul

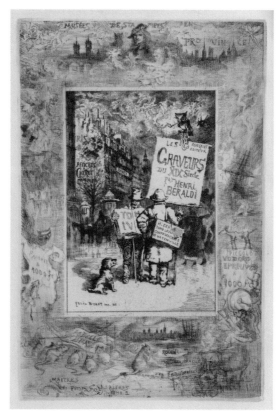

Left:
First state
Etching and drypoint on
simili-Japan paper
plate: 9⅞ x 7⅛ in.,
sheet: 13⅜ x 9¾ in.

Right:
Seventh state
Etching and drypoint on paper
plate: 8¾ x 5⅞ in.,
sheet: 9⅞ x 6⅝ in.

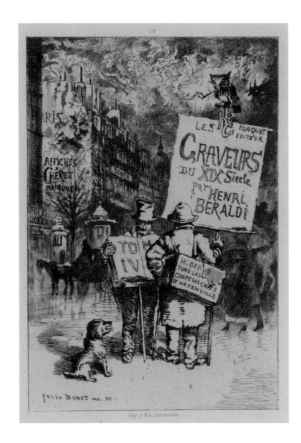

Seventh state, published frontispiece
Etching and drypoint on paper
image: 5 x 3½ in., plate: 7 x 4⅝ in.,
book: 10¼ x 7 in.

Letter from Henri Béraldi to Félix Buhot, March 19, 1886.
Translation:
*Bravo, Buhot! Excellent, Buhot. The book came out yesterday,
with the copies on big paper. Overall success! Triumph! The
people who only have the ordinary copies write me imploring
letters to have the symphonic margins!*
So thank you, my friend
H Béraldi

Les Pêcheurs d'Islande (Iceland Fishermen)
1886
Ink wash, gouache, gold and copper, graphite,
and white ink on paper
10⅞ x 14⅜ in.

Translated inscription: "Please find it in yourself, dear Monsieur Burty, to indulge this scribble that I perpetrated while reading the lovely book by Pierre Loti, Iceland Fishermen, that you lent me. Cordially yours, Félix Buhot."

Other annotations in the bottom margin indicate that Burty later lent the drawing to Frederick Keppel, a publisher and print dealer, for an exhibition in New York.

Les Pêcheurs d'Islande—named after Pierre Loti's treacherous tale of Breton fishermen—highlights the grandeur of nature, as well as the visual tropes, central to the Buhot prints. The foliage echoes the curving shape of the cliff in *La Falaise*, while other compositional elements (cross, boat, and geese) recall *Les Oies*. Buhot's inclusion of these components enables the drawing to conjure a combination of the sensations and moods from the prints.

—Andrea Tabora

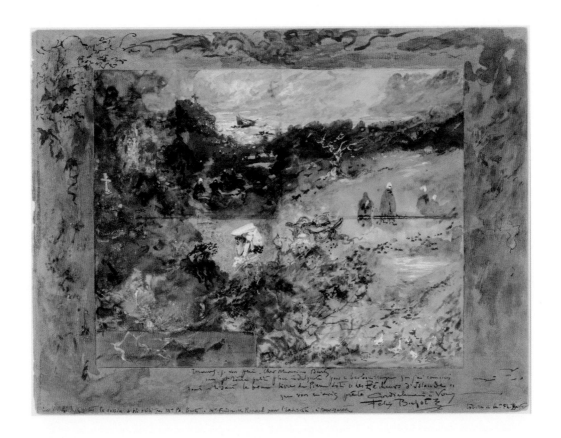

La Falaise – Baie de Saint-Malo
(The Cliff – Saint-Malo Bay)
B/G 165
c. 1889–90

The port town of Saint-Malo in northern France was home to French privateers and pirates known as corsairs. *La Falaise– Baie de Saint-Malo* hints at their activity through the fort and ships, but the real air of danger and mystery comes from the low vantage point of the heavily inked cliffs and the ominous, cloud-filled sky.

—Andrea Tabora

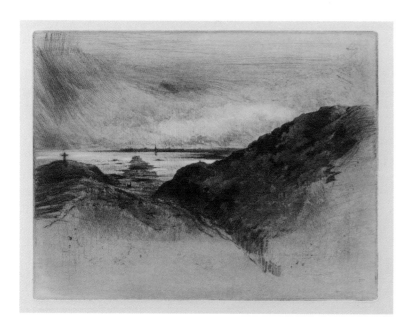

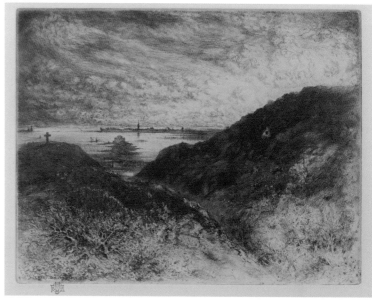

Second state
Etching, drypoint, and aquatint on paper
plate: 9 x 11¾ in., sheet: 12¼ x 17⅝ in.

Fifth state
Etching, drypoint, aquatint, and roulette over heliogravure on off-white wove paper
plate: 9 x 11⅝ in., sheet: 12⅝ x 17¼ in.

Les Oies **(The Geese)**
B/G 166
1884

Les Oies exudes serenity: Two women wash clothes in an open meadow behind a flock of elegant white geese. The tone of the sky and trees is diminished between the first and fifth states, and Buhot's use of line becomes more delicate and intricate, creating an atmosphere of stillness.

—Andrea Tabora

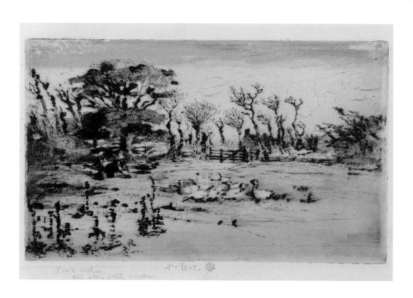

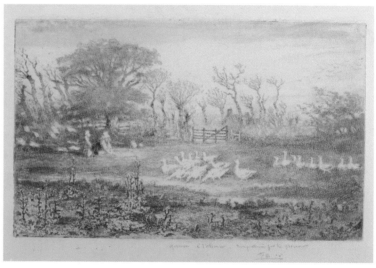

First state

Etching, drypoint, and aquatint on paper

plate: 6⅛ x 10⅛ in., sheet: 7½ x 12 in.

Fifth/sixth state

Etching, drypoint, and aquatint on paper; *épreuve à l'essence*

plate: 6⅛ x 10⅛ in., sheet: 8⅝ x 13⅜ in.

Frontispice pour **Zigzags d'un curieux,**
d'Octave Uzanne
B/G 172
1888

Not unlike *Le Hibou* (1883) (see pages 40–41), this frontispiece for Octave Uzanne's *Zigzags d'un curieux* features numerous elements of the macabre. From fluttering bats and perching owls to the black cat slinking across the foreground of the central image, Buhot's composition dramatizes his taste for dark and fantastic imagery.

A close friend of Buhot's, Uzanne would later write of how the "visionary" artist was forever "tortured by a crowd of fleeting impressions and queer ideas."[1] The first two states of this frontispiece certainly allude to such an artist, where lightly inked and indistinct scenes of the double margin overwhelm the composition. Although ultimately excised, the marginal sketches appear integral to the spirit of the final composition, offering a place on the plate for the artist's whimsical stream of consciousness.

—Charlotte Saul

1. Uzanne's assessment is quoted in "Félix Buhot, Etcher," ***Brush and Pencil*** 2, no. 6 (1898): 281.

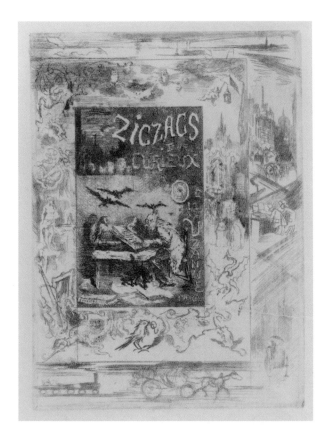

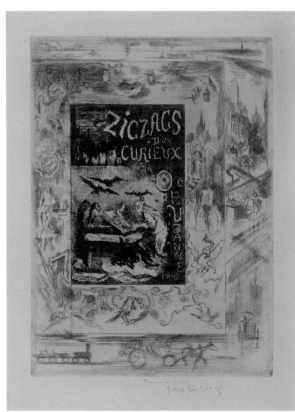

Left:
Second state
Etching on paper
plate: 9 x 6¾ in.,
sheet: 11¼ x 7⅞ in.

Right:
Second state
Etching on paper
plate: 9 x 6⅝ in.,
sheet: 11¼ x 8½ in.

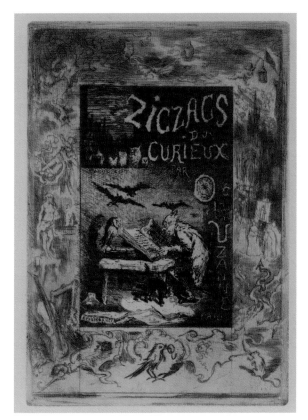

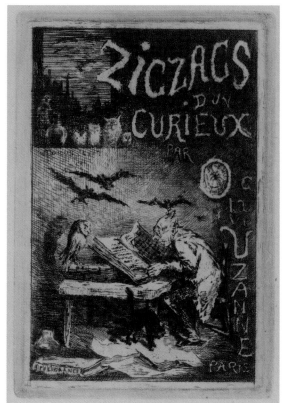

Left:
Fourth state
Etching on paper
plate: 7½ x 5¼ in.,
sheet: 10¼ x 7⅛ in.

Right:
Fifth state
Etching on paper
plate: 5½ x 3⅝ in.,
sheet: 9¾ x 6⅞ in.

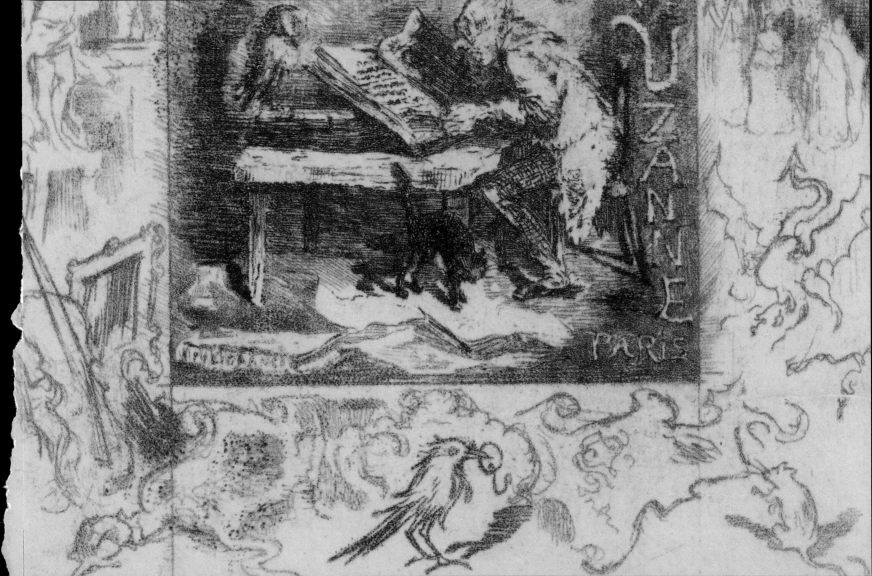

Printed in the United States of America

ISBN 978-0-935573-59-3

The exhibition *Expanding Narratives: Theme and Variations—
The Multiple Sorceries of Félix Buhot* appeared at the Smart Museum from
April 24 through July 22, 2018. Support for this exhibition was provided
by Mary Smart and the Smart Family Foundation of New York and by the
Smart Museum's Pamela and R. Christopher Hoehn-Saric Exhibition Fund.
Additional support was provided by the Museum's SmartPartners.

smartmuseum.uchicago.edu

Edited by
Anne Leonard
with assistance from Anne Ray

Design by
Karin Kuzniar Tweedie

Printed by
Lowitz & Sons

Photography by
Bruce Schwarz, except pages 15, 27 left,
33 right, 37 right, 47 left, and 51 photographed
by Michael Tropea.